FICTION OR FACTS

"ALLIGATORS"

Fact: "ALLIGATORS" are mean and hungry.

We are on their territory. You must RESPECT them

DON'T FEED THEM. DON'T WALK YOUR PET BY THE LAGOONS.

Do not try to retrieve a golf ball in marshes.

FICTION: ALLIGATORS MOVE SLOW WHEN THEY ARE ON LAND..

FACT: ALLIGATORS CAN RUN UP TO 20 MILES PER HOUR, BUT THEN AGAIN HE CAN ONLY RUN THAT FAST MORE A SHORT DISTANCE.

FICTION: ALLIGATORS ARE HUGE SOME UP TO 20 FEET THEY SAY AND WEIGH OVER A TON..

FACT: THE LONGEST ALLIGATOR WAS CAUGHT IN LOUISIANA BACK IN THE EARLY 1900'S IT WAS AROUND 19'2". MOST GATORS WONT GET LARGER THAN 13 FEET LONG AND AROUND 600 LBS OR MORE.

FICTION: ALLIGATORS LIVE A LONG TIME EVEN 100 OF YEARS.

FACT: IN THE WILD ALLIGATORS LIVE AROUND 30 - 50 YEARS, IN CAPTIVITY THEY LIVE LONGER AROUND 60 - UP. WITH ALL OUR TECHNOLOGY BUT WE STILL CAN'T TELL THE AGE OF AN ALLIGATOR WHILE HE IS ALIVE.

FICTION: ALLIGATORS WON'T DIE BY A POISONOUS SNAKE.

FACT: ALLIGATORS ARE NOT IMMUNE TO A POISONOUS SNAKE BITE BUT THEIR SKIN IS VERY HARD TO PENETRATE. (THE ARMORED BACK WITH BONEY PLATES CALLEDS SCUTES).

FICTION: ALLIGATORS AND CROCODILES MOUTH OPEN DIFFERENTLY, THE TOP PART IS HINGED TO THE JAW IN A CROC AND ALLIGATORS OPEN THE BOTTOM OF THE MOUTH.

FACT: ALLIGATORS AND CROCODILES ARE HINGED THE SAME.. THEY BOTH HINGE THEIR JAWS ON THE BOTTOM AND THE TOP JAW IS AN EXTENSION OF THE SCULL.

FICTION: YOU CAN ONLY EAT THE TAIL OF AN ALLIGATOR.

FACT: YOU CAN EAT JUST ABOUT EVERYTHING ON A GATOR BUT THE TAIL IS CONSIDERED BY SOME THE "PRIME CUT".

To order additional copies of this book, contact:
Xlibris
844-714-8691
www.Xlibris.com
Orders@Xlibris.com

ISBN: Softcover 978-1-5434-9861-5
 EBook 978-1-5434-9860-8

Print information available on the last page

Rev. date: 01/07/2022

BOOK AND COVER DESIGN BY

Joseph Lawski and Ralph Sutton

This book is printed in the United States of America.

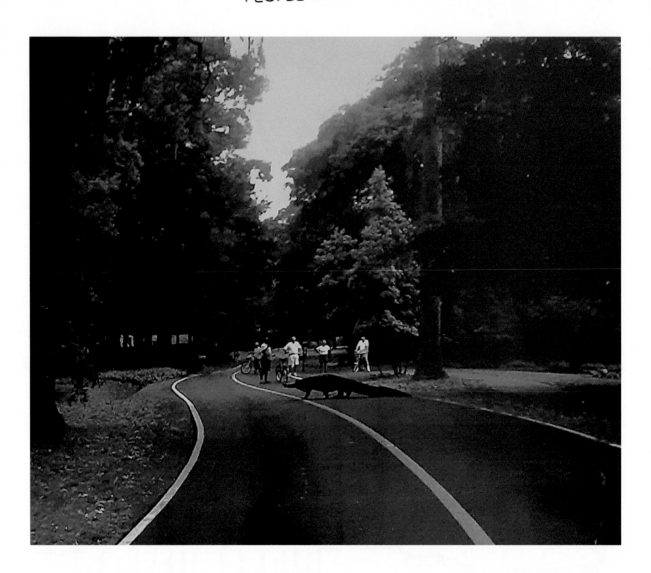

OH, OH THAT DIDN'T WORK

BUT THIS BOOK IS NOT ABOUT *ME...*

IT'S ABOUT OUR LOCAL
HILTON HEAD "GATORS"
THAT RUN AROUND
"FREE"

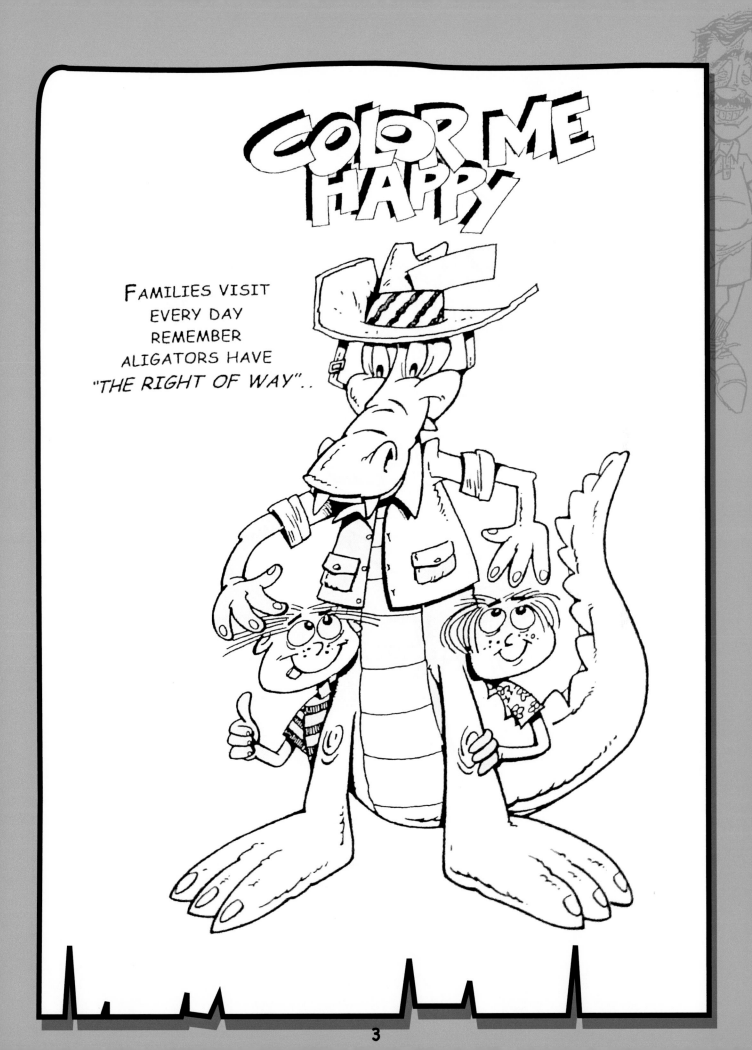

IF YOU GET LOST
HAVE NO FEAR
JUST LOOK FOR THE SIGN
THAT READS...

YOU ARE HERE!

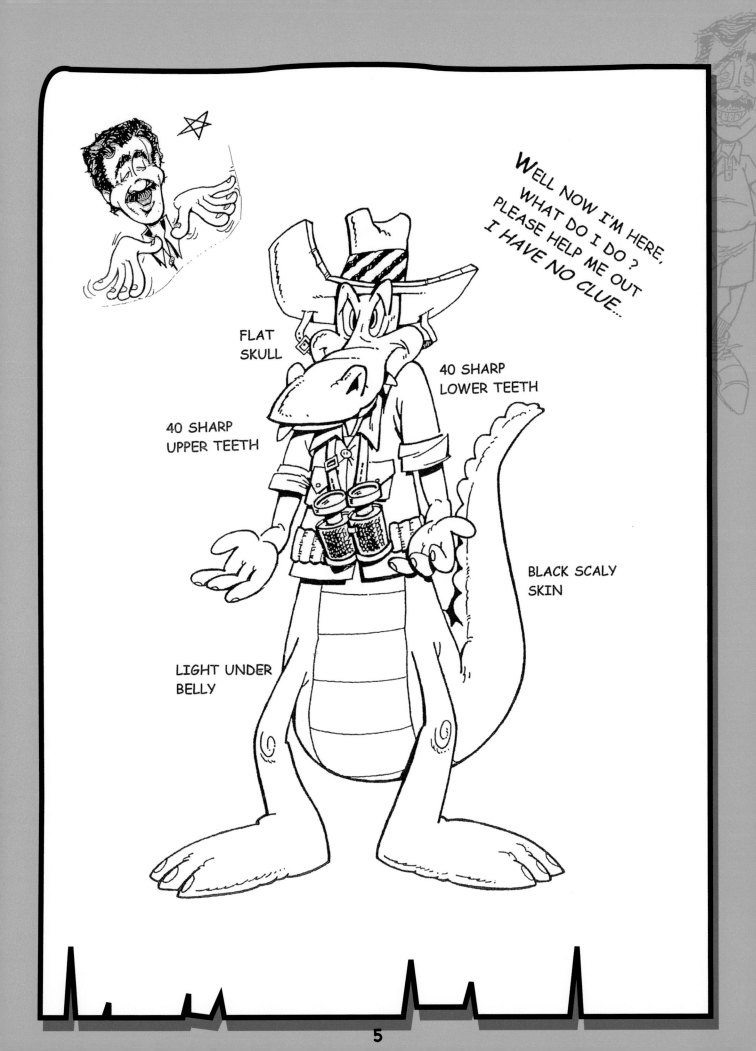

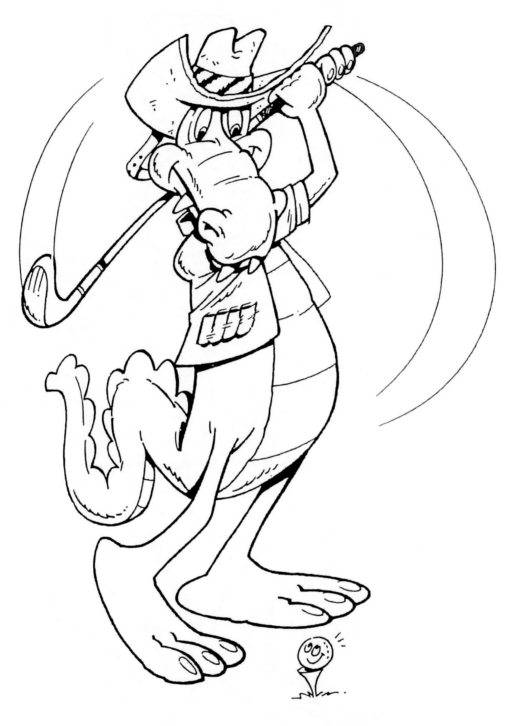

SWING AND MISS MY ARMS ARE SORE
BUT WHEN YOU HIT
YELL REAL LOUD
"FORE"

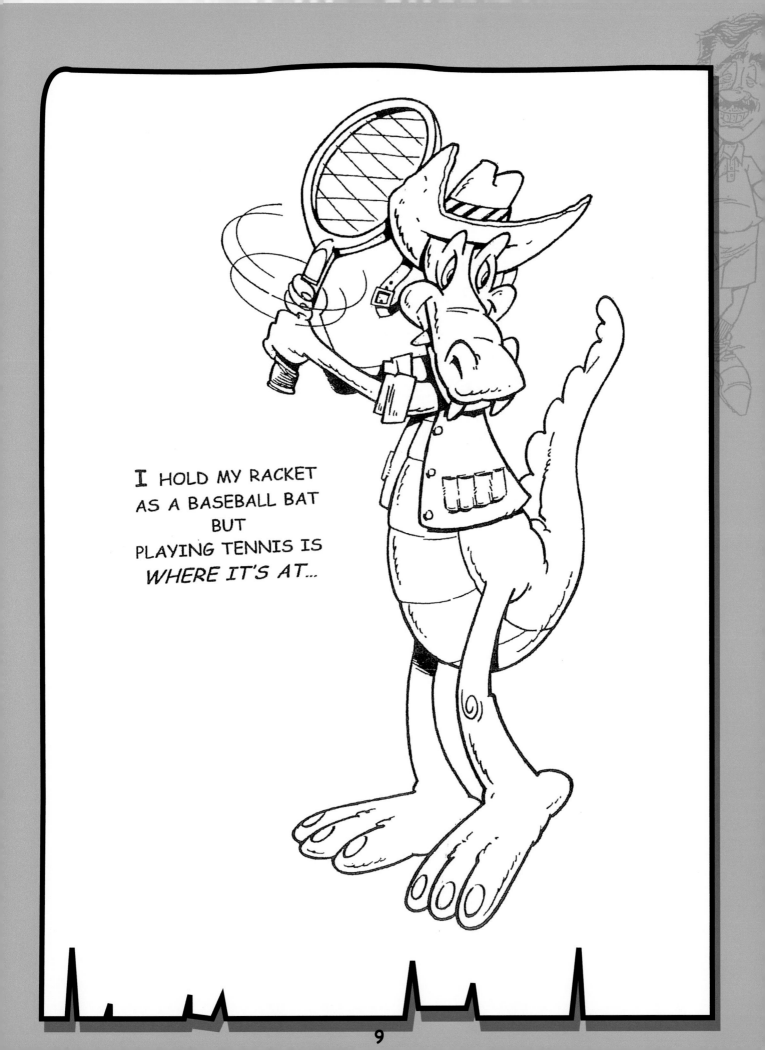

I HOLD MY RACKET
AS A BASEBALL BAT
BUT
PLAYING TENNIS IS
WHERE IT'S AT...

A ROMANTIC DINNER JUST FOR TWO

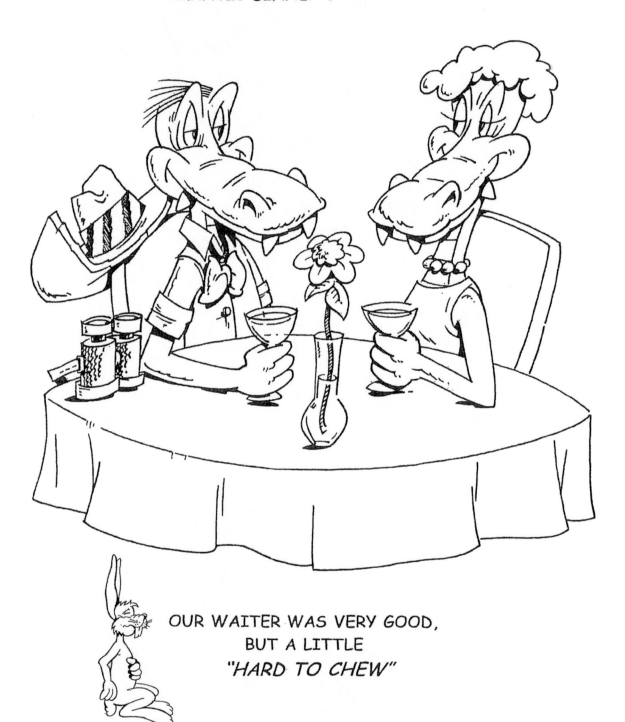

OUR WAITER WAS VERY GOOD,
BUT A LITTLE
"HARD TO CHEW"

THE BIRDIE ON MY KNEE
YUMMY HE
LOOKS LIKE BAIT
BUT RIGHT NOW I'D RATHER
DRINK A "GATOR-AID"..

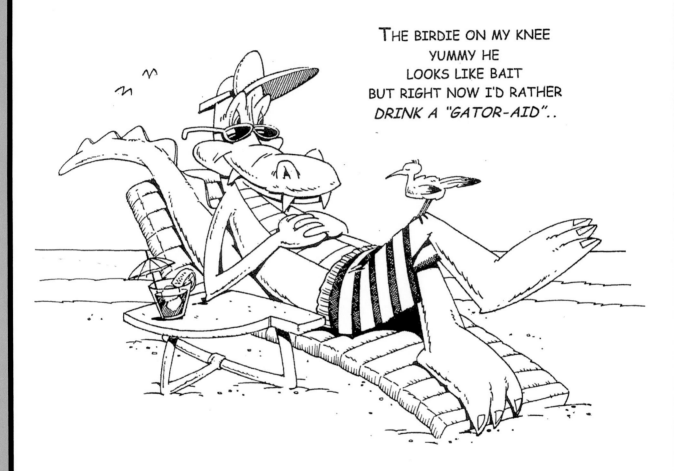

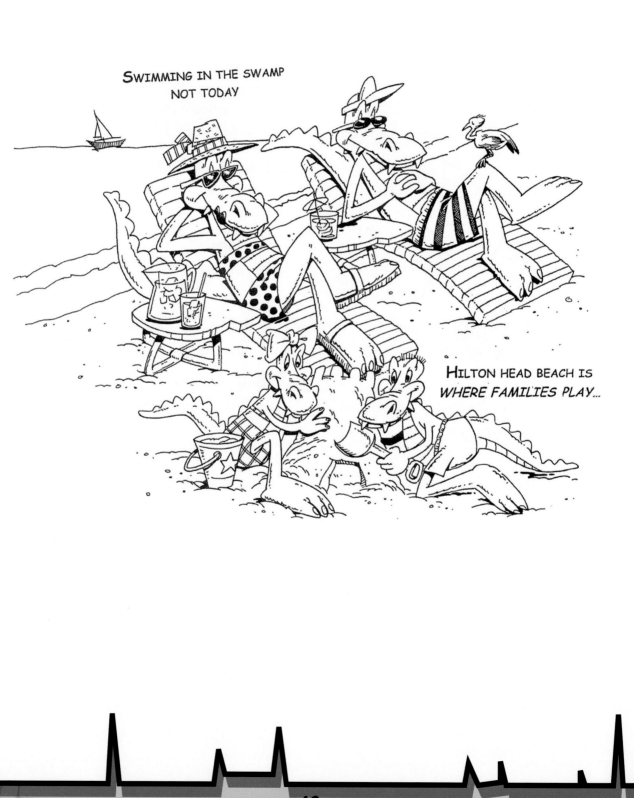

GERONIMO, HERE I GO
IN THE POOL
ACTING LIKE A FOOL...

TO GIVE THIS BOOK A LITTLE MIX
HERE ARE
SOME
"MAGIC TRICKS"

PICK A NUMBER TRICK

1. First read all instructions & directions:
2. On the bottom of this page are

 "secret numbers"
 box 1 – box 6 (left)
 add numbers (right)

3. Cut or Copy the "secret number" section from the bottom of this page.
4. Have mom/dad "think" of a number from (1–63).

 Then turn to page (3) "boxes of #'s" and hand them this book.

5. Turn your back and look at the "secret numbers" (don't let anyone see you do that)

CUT HERE

(SECRET NUMBERS) WHAT EVER BOX NUMBER THEY SAY
(LEFT) (RIGHT) "ADD" THE NUMBERS ON THE RIGHT TOGETHER
BOX 1 – ADD THE NUMBER 8
BOX 2 – ADD THE NUMBER 2
BOX 3 – ADD THE NUMBER 16
BOX 4 – ADD THE NUMBER 4
BOX 5 – ADD THE NUMBER 32
BOX 6 – ADD THE NUMBER 1
 (TOTAL = THIS IS THE NUMBER THEY PICKED) SAY OUT-LOUD

6. HAVE THEM LOOK INTO EACH BOX
 (ONE AT THE TIME).
7. WHEN THEY SEE THEIR NUMBER IN A BOX, HAVE THEM SAY OUT-LOUD ONLY "THE BOX #", (IF IT'S NOT IN
 A BOX, LOOK IN TO NEXT BOX), AND SO ON.
8. WHEN THEY ARE "DONE"
9. HAVE THEM SAY "FINISHED"

EXAMPLE:

IF THEIR NUMBER IS IN (BOX 1), (BOX 2), + (BOX 6)

THEY MUST SAY IT'S IN (BOX 1, (BOX 2), + (BOX 6)

3. MOM / DAD

LET'S RE-CAP

- THINK OF A NUMBER FROM 1 THROUGH 63.
 (SEE OTHER SIDE)
- HERE YOU HAVE (6) BOXES WITH NUMBERS,
 (BOX 1 - BOX 6)
- LOOK THROUGH EACH BOX OF NUMBERS (CAREFULLY),

IF YOU SEE "YOUR" NUMBER IN THE BOX
TELL HIM THE BOX # ONLY

IF IT IS NOT, LOOK INTO THE NEXT BOX
DO THIS WITH ALL 6 BOXES AND WHEN YOU'RE DONE
TELL HIM YOU'RE FINISHED

SAY TO HIM:

"OK" SMARTY PANTS...WHAT'S MY NUMBER

HE WILL THEN BE ABLE TO TELL YOU THE NUMBER YOU
PICKED.

LIKE
"MAGIC".

PLEASE TURN PAGE

BOX 1

8	9	10	11	12	13
14	15	24	25	26	27
28	29	30	31	40	41
42	43	44	45	46	47
56	57	58	59	60	61
62					

BOX 2

2	3	6	7	10	11
14	15	18	19	22	23
26	27	30	31	34	35
38	39	42	43	46	47
50	51	54	55	58	59
62					

BOX 3

16	17	18	19	20	21
22	23	24	25	26	27
28	29	30	31	48	49
50	51	52	53	54	55
56	57	58	59	60	61
62					

BOX 4

32	33	34	35	36	37
38	39	40	41	42	43
44	45	46	47	48	49
50	51	52	53	54	55
56	57	58	59	60	61
62					

BOX 5

4	5	6	7	12	13
14	15	20	21	22	23
28	29	30	31	36	37
38	39	44	45	46	47
52	53	54	55	60	61
62					

BOX 6

1	3	5	7	9	11
13	15	17	19	21	23
25	27	29	31	33	35
37	39	41	43	45	47
49	51	53	55	57	59
61					

PLEASE MR. HUMAN
DON'T BE RUDE, I WOULD LOVE TO EAT
SOME HUMAN
FOOD..

CAN'T WE JUST GET ALONG
AND HAVE SOME FUN
COME ON PLEASE, FETCH THE HOT DOG
AND THE BUN...

OK, OK BUT YOU'LL HAVE TO CHOOSE
YOU GET THE HOT DOG AND THE BUN
AND I GET
ALIGATOR SHOES..

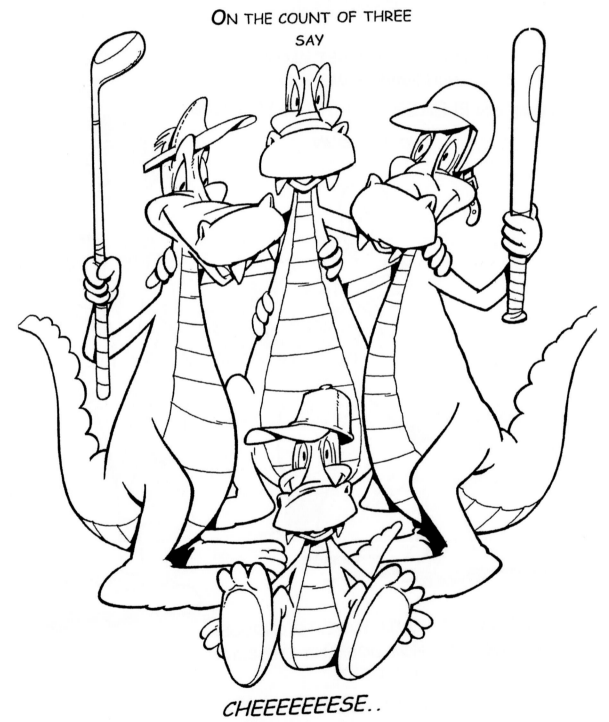

My name is Joseph Lawski / Longo ...You may also know me as "Joseph the Magician". Let me tell you just a little about myself..

(1) I was Born and Raised in - Germany. (1948 - 1960).. I was 13 years old when I moved to America, English is my 2nd language..(If I can Learn to speak English..So can ANYONE Else)..

(2) I Arrived in America - (1960)..Columbus Ga. I started to attend American school in the 8th grade..I always tell everyone that I was the smartest KID in the 8th grade for 3 years in a Row..

(3) AFLAC - Computer Operator (1967) > (1969).. I was very Blessed to have been chosen by American Family Life Assurance president Mr. John Amos to operate their IBM 1401 computer in 1966 and I was only in the 9th grade..after I graduated from high school 1967 aflac send me to Columbus Tech for an assoc. degree in Computer Programming..I graduated in 1969 and held my position as a operator for about 1 year and then I was drafted in the Serive 1969, (Viet Nam) I was honorably discharged from the Navy after a 4 year Tour..But AFLAC did not save my position in the computer room after I returned from duty..(They were too big now) AFLAC Violated the Verteran Re=Employment Act of 1974..(WHAT TO DO...WHAT TO DO..?? Stay Tuned..

(4) US Navy (1969 > 1974).... The first duty station was BEAUFORT, SC Naval Hospital..I was billed as a Data processing Tech..for the first year then was assigned to the USS FULTON which was a Nuclear Submarine Tender..Got out in 1974 and went to work Civil Service on the Kitty Hwak aircraft Carrier, San Diego.

(5) Civil Service - Computer Specialist GS-9 San Diego, (1975 > 1980)..

(6) Professional Magician - (1981 > 1989) San Diego.

(7) Magician, Hilton Head Island, SC - (1990 > 2009)..

(8) Found my Bio-logical Father on Fathers Day 1996 at Damon's Restaurant

Printed in the United States
by Baker & Taylor Publisher Services